CHRISTOPHER HART'S
DRAW MANGA NOW!

Supercute Animals and Pets

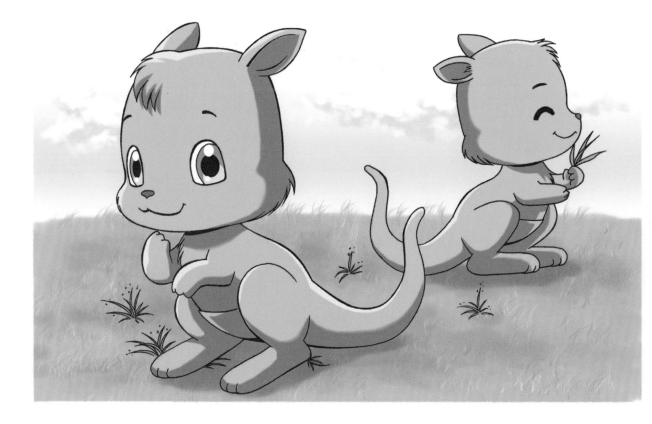

CHRISTOPHER HART'S DRAW MANGA NOW!

Supercute Animals and Pets

Christopher Hart

Watson-Guptill Publications
New York

Published in the United States by Watson-Guptill Publications, an imprint of the Crown Publishing Group, a division of Random House LLC, a Penguin Random House Company, New York.

www.crownpublishing.com
www.watsonguptill.com

WATSON-GUPTILL and the WG and Horse designs are registered trademarks of Random House LLC.

This work is based on the following titles by Christopher Hart published by Watson-Guptill Publications, an imprint of the Crown Publishing Group, a division of Random House LLC.: *Manga for the Beginner*, copyright © 2008 by Starfire LLC; and *Manga for the Beginner Chibis*, copyright © 2010 by Star Fire LLC.

Library of Congress Cataloging-in-Publication Data

Hart, Christopher
Christopher Hart's draw manga now!: supercute animals and pets/Christopher Hart.—First edition.
 p. cm
1. Comic books, strips, etc.—Japan—Technique. 2. Cartooning—Technique. 3. Animals in art. I. Title. II. Title: Supercute animals and pets.
 NC1764.8.A54H379 2013
 741.5'1—dc23 2013028863

ISBN 978-0-378-34601-6
eISBN 978-0-385-34602-3

Cover and book design by Ken Crossland
Printed in China

10 9 8 7 6 5 4
First Edition

Contents

Introduction

Everyone loves pets and animals, and we all have our favorite ones. In this book, we'll learn how to draw irresistible furry friends, sleek sea creatures, and exotic critters in the manga style, making them extra cute. If you want to learn how to draw adorable animals, look no further—this is the book that will teach you.

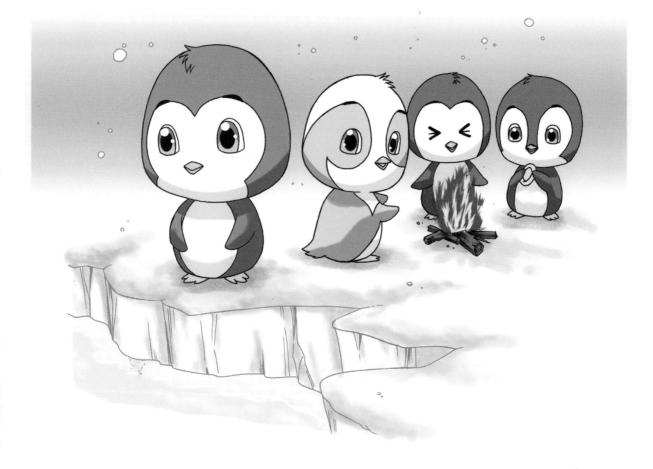

To the Reader

This book may look small, but it's jam-packed with information, artwork, and instruction to help you learn how to draw manga like a master!

We'll start off by going over some familiar, favorite animals, the basics that go into drawing them, and the details that make these animals look unique. Pay close attention; the material we cover here is very important. You might want to practice drawing some of the things in this section, like eyes and faces, on your own.

Next, it'll be time to pick up your pencil and get drawing! Follow along my step-by-step drawings on a separate piece of paper. When you draw the characters in this section, you'll be using everything you learned so far.

Finally, I'll put you to the test! The last section of this book features drawings that have appeared elsewhere in my book, except they'll be missing some key features. It's your job to finish these drawings, giving animals the stripes, legs, tails, and even manga friends that they need.

This book is all about learning, practicing, and, most important, having fun. Don't be afraid to make mistakes, because let's face it: every artist does at some point. Also, the examples and step-by-steps in this book are meant to be guides. Feel free to elaborate and embellish them as you wish. Before you know it, you'll be a manga artist in your own right!

Let's begin!

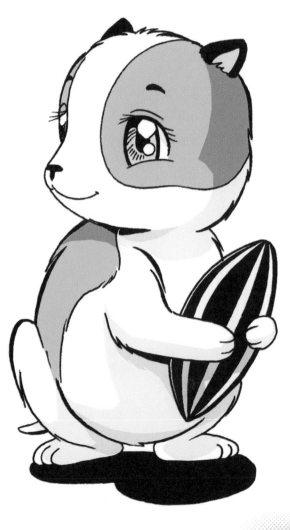

PART ONE
Let's Learn It

Domestic Animals

Here come the friendly, familiar, furry faces of dogs and cats. Except we'll be looking at how to make them look distinctly manga, complete with big eyes, cute little snouts, and simplified body structures. Feel free to have fun and play with the coloring, ears, and tails of each type to make them your own.

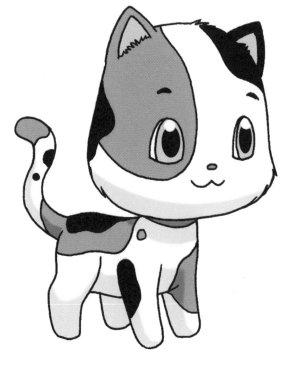

Dogs and Puppies

Playful Pup

The head of the puppy is based on a circle. Add some mass on the sides to make adorable, plump cheeks. How's that for easy? The body is shaped like an elongated oval, a very simple form. No neck is necessary. When drawing the body, make sure all the edges are rounded—the body should be more oval-shaped than square.

Puppies always have short tails and small noses. Their paws are also oversized.

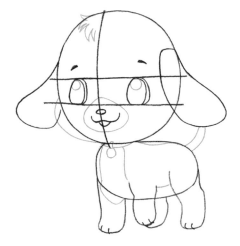

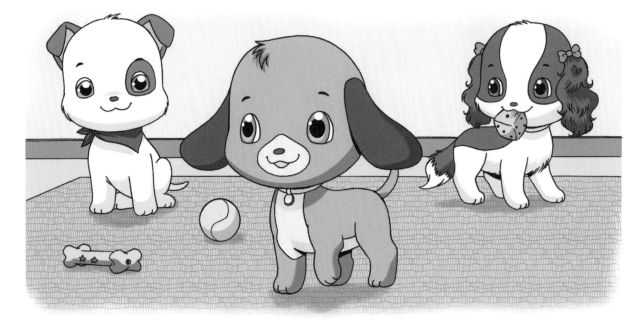

Add mass for cheek area.

Older Dog

This dog is a little more elaborate. His legs have more detail, with circles indicating the joints. The body is built on two circles. Note that the tongue hanging out and one ear up is a happy expression, unless you're a person, in which case, it's just weird.

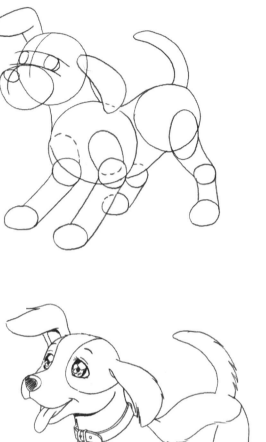

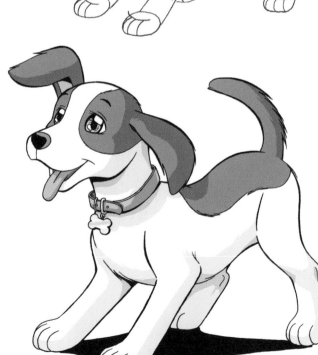

Cats and Kittens

Cute Kittens

Kittens should always look soft and fluffy. Starting with the head, draw a large circle. However, felines have ruffles on the sides of their faces. The nose is just a tiny pink dot. Cat ears are drawn as little triangles. Notice, too, the split upper lip.

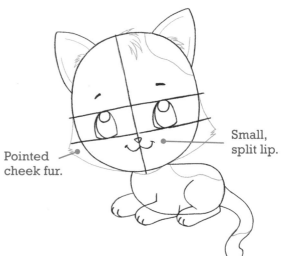

Pointed cheek fur.

Small, split lip.

Quick Tip
The horizontal lower eyelids make the character look like she's smiling.

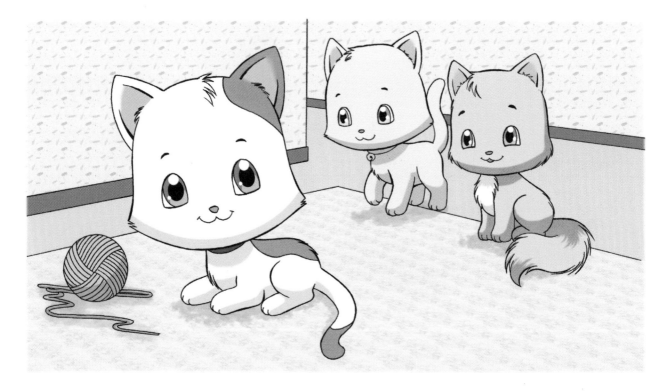

Sitting Cat

This cat's body is a little more developed than the kitten's, based on two circles instead of one. Its fur is also much thicker and bushier. You'll notice, however, that the face shape is the same, and the cat still has big, shimmering eyes.

Different Breeds

If you can get the hang of the basic head construction of a dog or cat, you can easily change the breed of animal you're drawing, just by making a few modifications. Try playing with the shapes of the ears, the coloring or markings of the fur, and the shape of the tail. Here's a gallery of different breeds of dogs and cats. You can use these as reference, or invent your own breed!

Dog Breeds

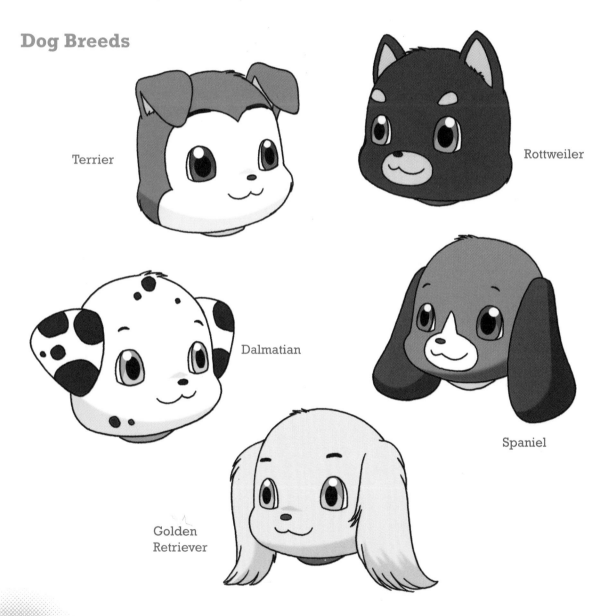

Terrier

Rottweiler

Dalmatian

Spaniel

Golden Retriever

Cat Breeds

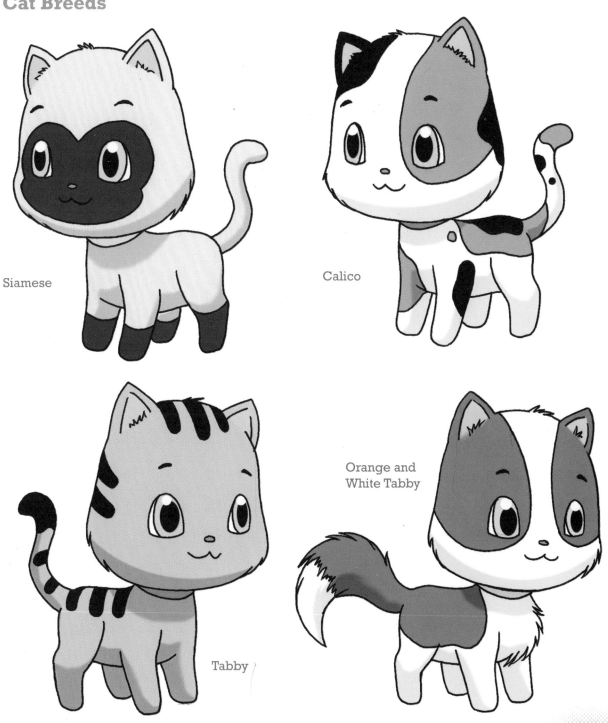

Siamese

Calico

Tabby

Orange and
White Tabby

Backyard Buddies

Depending on where you live, you might see some of these animals, large and small, in your backyard. They are tiny, miniature versions of themselves, which makes them look adorable. This not only gives them a sweet look, but makes them appear a little comical, as well.

Busy Beavers

The hallmarks of this hardworking animal are its buckteeth, wide cheeks, small rounded ears, and, of course, its long, flattened tail. The beaver, in reality, has a small head on top of a large body; however, you should take artistic license and reverse this so that the manga version has a huge head on top of a small body; it's much cuter. Give him fat cheeks, and ruffle the fur to emphasize the fact that he chews a lot and that his jaw is hard at work. You can give the beaver a single bucktooth or two.

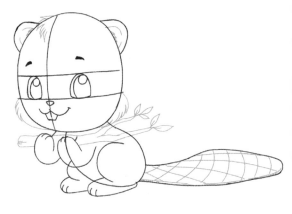

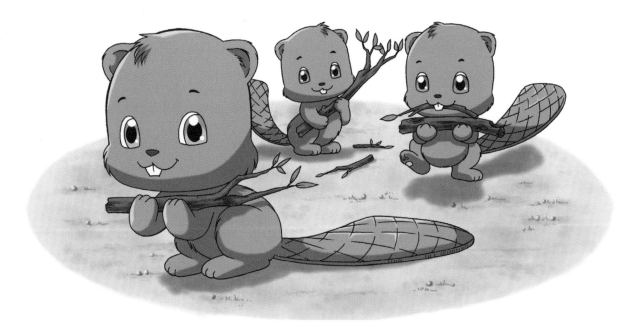

Sneaky Foxes

Foxes are small, even smaller than dogs. In reality, their faces are pointed. But to make a manga fox, you have to adjust the face a little. Shorten the snout, but keep the sides of the face pointy to maintain the original foxlike quality of the animal. Make the tail as bushy as possible. And although in real life the tip of the tail is sometimes dark, in cartoons it's always depicted with a white tip. The paws remain dark, just as they are on real foxes. That should be enough to "manga-fy" the fox and still make it recognizable.

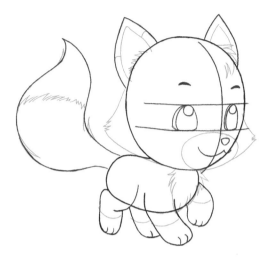

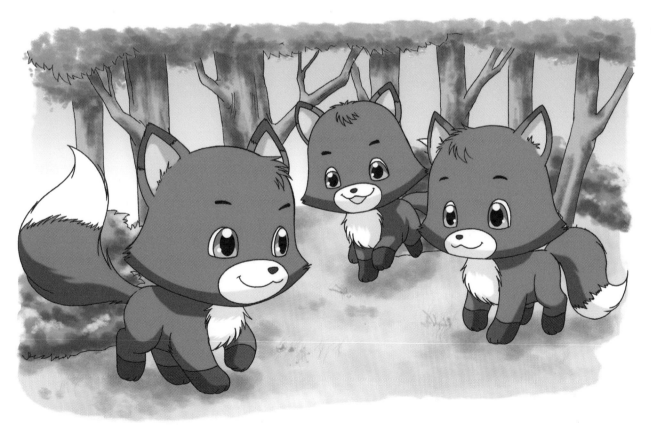

Cuddly Bear Cubs

Bears are often portrayed in humorous sitting poses, because real bears actually do sit like this! This is one of the easiest animal poses to sketch, because it mirrors a human sitting position. Everything about this character is round and fuzzy. And this roundness pulls at people's heartstrings. The bear has an oval for a body, small ears, a split lip, and a stubby tail. And that's all there is to him.

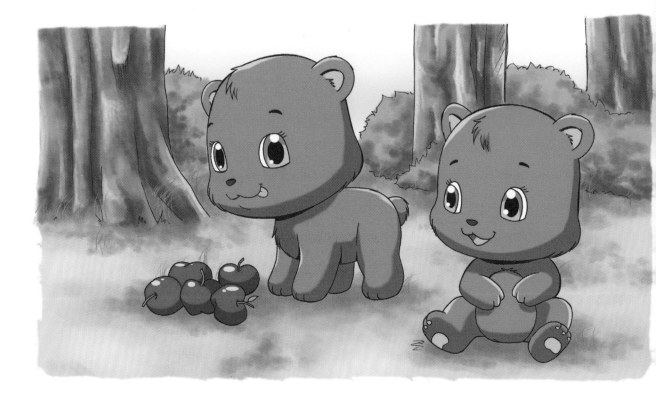

Even More Bears

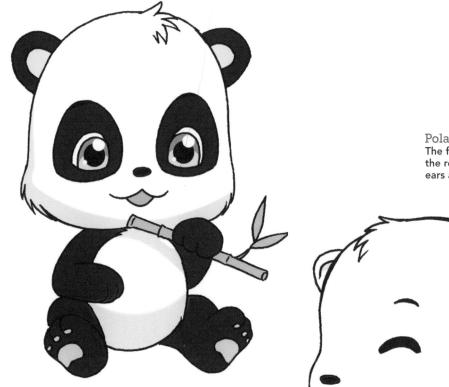

Polar Bear
The face is a little pointier than the regular brown bear, and the ears are even a little smaller.

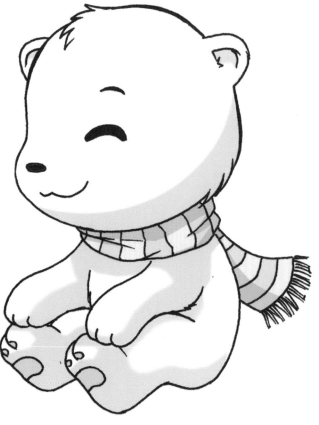

Panda
These are the classic markings for the famous panda, perhaps the world's most beloved exotic animal, not to mention a well-known mascot in manga.

Grazing Cows

Cows are sweet, docile animals, and it's easy to make them adorable. The ears stick out diagonally from the head, but the horns sit directly on top. Keep the horns small—only bulls have large horns. The muzzle is an oval shape. Dainty little nostrils keep the character looking young, as do the eyelashes. These little cows have an exaggerated hoof size, but don't draw the legs too thick. Thicker legs would result in too sturdy and strong a look for a cute character. Ruffle the fur just above the hooves. You can play with the markings, as some cows have large, splotchy spots and others have none. The tail is long and thin, with a fluffy dollop of fur at the end.

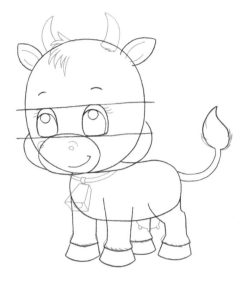

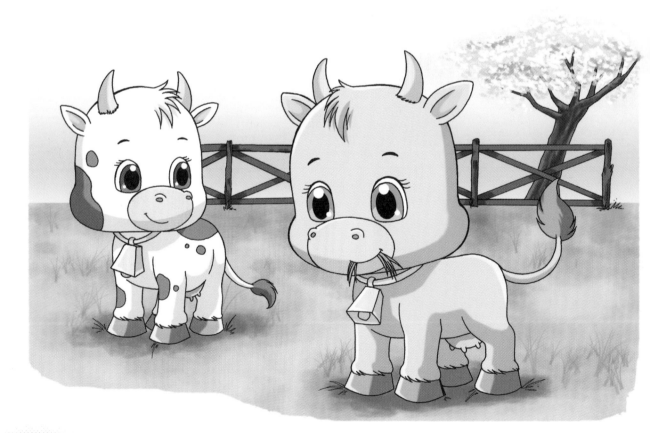

Rascal Raccoons

Here's a bright-eyed troublemaker everyone loves. Raccoons are hyperactive, and always getting into everything. They can run on all fours or in a human posture. At the bottom of the head, which is shaped like a circle, we've added a football-shaped area for the mouth. The ears are pointed, like cat ears. Don't forget the markings, especially the eye mask and rings around the fluffy tail. They make the raccoon unique.

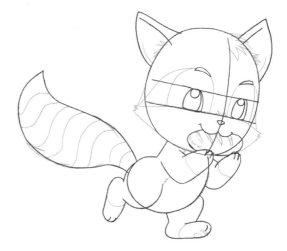

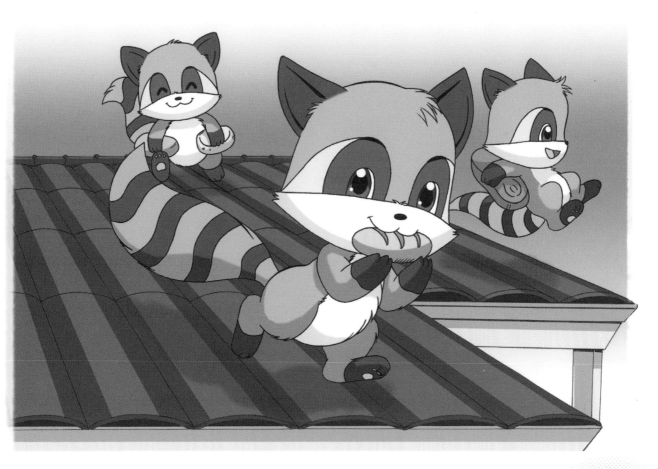

Bouncing Bunnies

Bunnies also have chubby cheeks with ruffled fur. The head construction is based on a rounded square, with chubby cheeks at the bottom. The nose can be pink or black, but pink tends to look cuter. As for the body, the plump thighs give the bottom a chubby look, which makes this bunny cuter—if that's even possible. The tail is a bushy fuzz ball. And notice that tuft of fur added to the chest, which makes bunnies look soft and squeezable. Like a scarf that blows in the wind, the long, floppy ears indicate movement and add to the sense of motion.

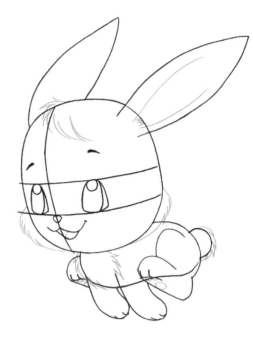

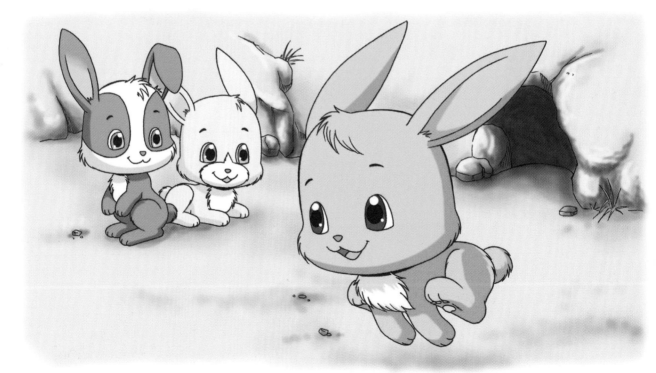

Rabbit

This rabbit stands upright, on flat, sturdy feet. It has chubby thighs and lots of fluffy fur on its chest and cheeks. Don't forget the fluffy cotton tail—even if you alter the color or markings of the rabbit, the tail always makes it recognizable.

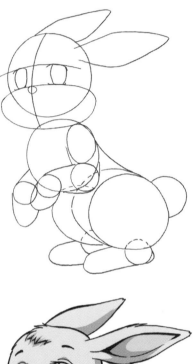

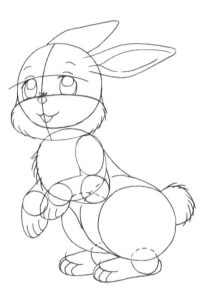

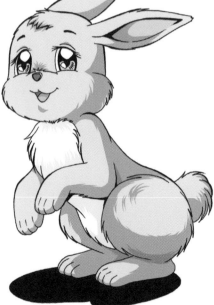

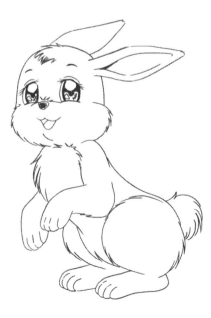

Sea Creatures

The water-dwellers you see here have a body construction that's quite different from land-dwellers'. Rather than making these critters look fluffy, as you might have done before, try making them look slick and smooth. They are also more vertically oriented and have simpler colorings and markings.

Precious Penguins

Real penguins have super-small heads on long bodies. But to create cute, manga penguins, use the proportions of babies. That means oversized heads on tiny bodies. That also means that the facial features mimic those of children: big eyes and a tiny mouth—or beak, in this case. There is no neck; the head rests directly on the shoulders. The body is quite plump, with shortened flippers for arms (real penguins have long flippers). You can vary the markings, so long as the center of the body and face remain white.

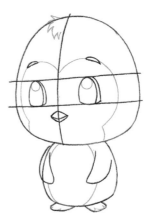

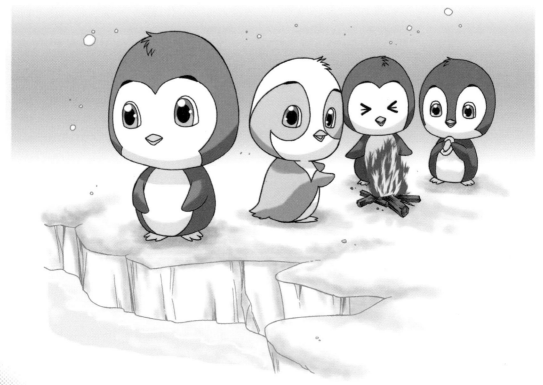

Dancing Sharks

Even sharks can be adorable! Built like bodybuilders, these sharks are narrow at the waist but big around the chest. The snout protrudes, and sharp teeth show at all times. The eyes are almond shaped instead of circular. Round eyes are the trademark of harmless animals, and even though sharks are playful, we can't get away from the fact that they're predators—and the almond-shaped eyes signify that. As far as markings, sharks are two-toned: white around the mouth and belly, grayish blue everywhere else.

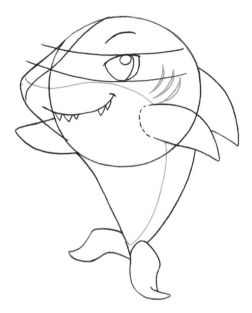

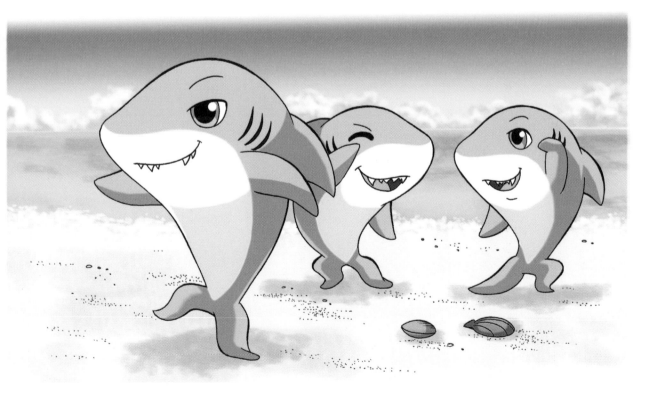

Exotic Animals

Let's look at some animals that we don't see every day. Although these animals are exotic, they rely on similar body constructions and features that we've covered earlier. These animals are good examples of how you can modify and tweak the basics that you know in order to create exciting, new drawings.

Tiger Cubs

Tigers are generally a little shaggy, so ruffle the fur around the ears, on the top and sides of the head, just over the nose, and on the chest. Note that the nose isn't a circle or an oval but dips slightly in the middle. This happens on other large cats, such as lions, too. Just as on their relatives, domestic cats, tigers have a split upper lip. Their ears are more round than they are pointy. Although the tiger cub has lots of stripes, it's best to limit the amount on the face, or you'll make the character look cluttered. Notice that the stripes have been left off the areas around the eyes, nose, and mouth. Instead, they are most prominent on the forehead, back, and tail.

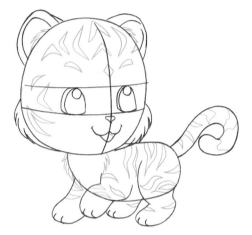

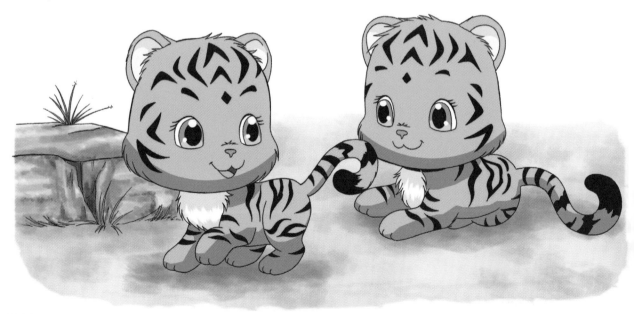

Kangaroos

Everyone knows that kangaroos have pouches. But something else they have, which you may not be aware of, is a long and strong tail. It's quite thick at its base, where it attaches to the back. Also, kangaroos have long ears, but we'll shrink them a little here. Their head is shaped similarly to the beaver's, and they have a small tuft of fur on the top of their head. Their posture has them always leaning slightly forward. In this natural resting position, the knees rise up high on the body, almost to the chest. They're pudgy-cute, with little arms that are almost useless and extra-long feet that lie flat on the ground.

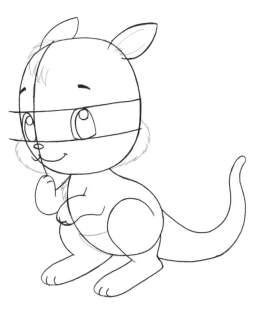

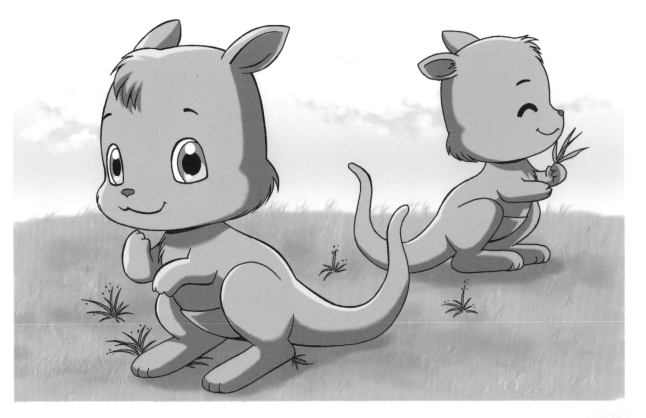

Important Details

Let's take a look at the small yet very important elements that will help you draw each animal accurately. If you can get a handle on details such as facial proportions and leg and foot construction and markings, you'll be able to experiment with other aspects of the animal and keep it looking cute and recognizable.

Basic Head Constructions

Bunny

When the ears flop over, reference how big they are in the straightened position to get the correct length in the bent position. The profile lets you see the bent ears in place and also affords a good look at the relationships of the features: The nose and the bottom of the eye are at the same level, and the distance from the top of the eye to the base of the ear matches the distance from the bottom of the eye to the bottom of the head. Note, too, that the base of the ear is placed a little below the line of the top of the skull.

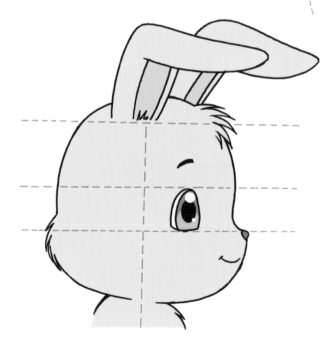

Raccoon

The eyes take up half the total height of the eye markings. The ears begin where the skull starts to curve downward around the sides of the head.

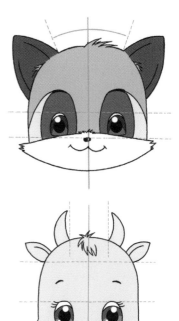

Cow

The bottom of the eye rests on the same guideline as the top of the muzzle. The forehead is almost two eye lengths tall, and the ears start at that point. The horns are between the ears and more upright.

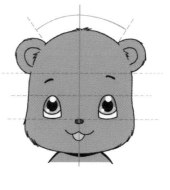

Bear

The nose and the bottom of the eyes rest on the same line. The eyebrows and the bottom of the ears are at the same level. The space between the top of the eyes and the bottom of the ears is the same length as the eye itself. As with the raccoon, the ears fall where the top of the skull starts to curve strongly down the sides of the head.

Kangaroo

This kangaroo's head is shaped similarly to the beaver's and kangaroos have a little tuft of fur on the top of their head. Like a cat, they have a split upper lip. Their ears sit closer to the top of the head, before the head starts to slope downward.

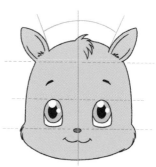

Limbs

Regardless of the animal, you'll have to draw their legs, hooves, fins, tail, or feet. Here are a few examples that you can apply to any animal you draw.

Hooves

Hooves are round, not straight. And you can clearly see this when they're raised off the ground and you look at the underside. For a cute look, try widening the legs as they reach the hooves. You could draw horse hooves this way, too.

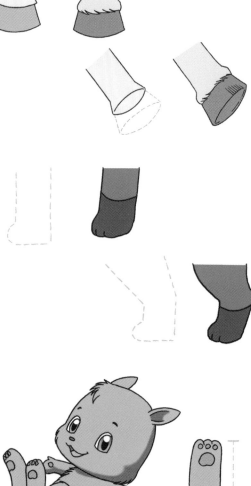

Legs

The front legs on four-legged animals like foxes, dogs, cats, bears, and others are mostly straight, while the back legs are curved and much plumper. To draw the hind legs, think about angling your lines backward, toward the rear of the animal. Their paws are a modified circle; they are round, but flatten at the bottom where the paw would meet the ground.

Feet

This is a kangaroo's foot. As you can see, it's pretty long, which makes it great for hopping! Other animals' paws probably won't be this long but will be similarly shaped—particularly the rabbit's. Try playing around with this paw and experiment until you find one that looks right on the animal you are trying to draw.

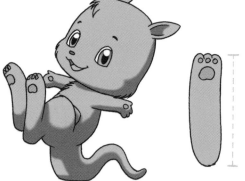

Tails

A beaver's tail is shaped like a triangle, but without a pointed top. After drawing the shape, try getting the texture down. First draw the crosshatching, then erase some parts, and you'll have the look of the tail's texture.

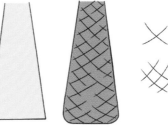

Fins

The dorsal fin attaches to the center line, which runs down the middle of the back.

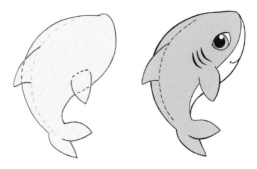

Stripes

Raccoon Tails

When drawing stripes on a tail, make sure they curve around that tail; they're not straight lines.

Tiger Stripes

The stripes curve in the center and taper at the ends. They can be solid black or have an open area in the center where the tiger's orange coloring shows through—they can even remain open at one end. It's good to mix 'em up. The arrows on this tiger's body show the positions and directions of the stripes. You could try drawing these on a kitten, too.

Beaks

This doesn't only apply to penguins; most birds' beaks, when drawn in the manga style, will appear this way. In the side view, the beak looks like two triangles stacked on top of each other. In the 3/4 and front views, the top part of the beak is affected by perspective, and becomes a diamond shape. The bottom part of the beak is "v-shaped." Being able to draw the beak from different angles will be very handy as you draw your own cute manga birds, especially when drawing them in different situations.

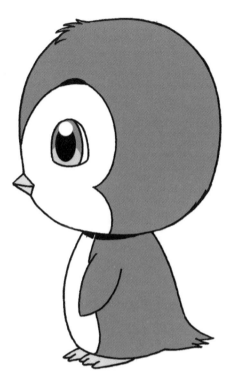

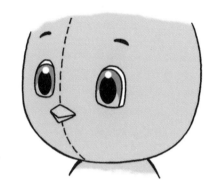

3/4 View

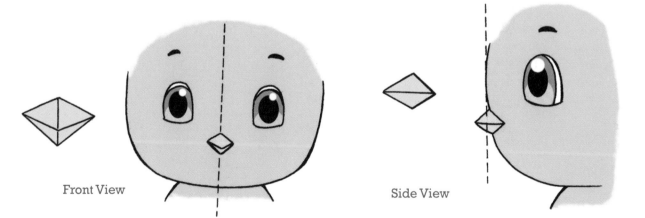

Front View

Side View

Favorite Toys

All pets and animals have their favorite kinds of toys, food, and mischief they like to get into. Have fun using these special "add-ons" in a scene to create a cozy environment for your manga animals. Dogs and cats love toys, balls, and couches to snuggle on. Unfortunately, they also love digging up plants and flowers!

Balls and Toys

Comfy Couches
and Cushions

Plants to Dig Up

Kawaii Animals

The animals shown here are drawn in the outrageously cute style of manga known as kawaii. These kinds of animals come in many different shapes, but you can't just draw a small, cute version of an animal and expect it to look "kawaii." Instead, here are some tips on style that will help you achieve this adorable look. Kawaii animals' bodies are compact and round, without much detail. Their heads are oversized and round, too. In some cases, their heads and their bodies are the same object! Finally, kawaii animals are always cheery-looking.

Jellyfish

Hedgehog

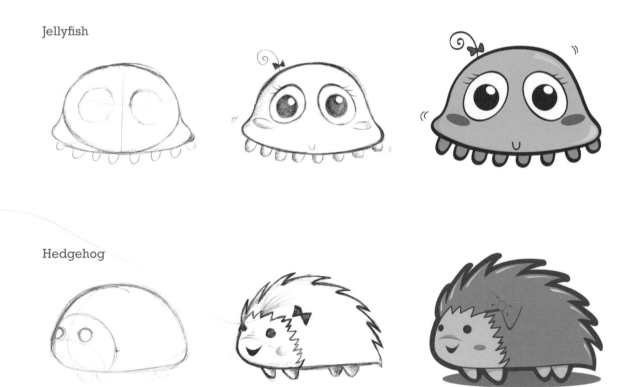

Squirrel

 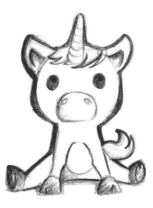 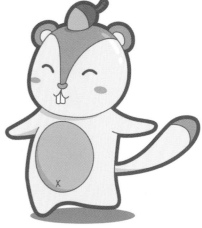

Unicorn

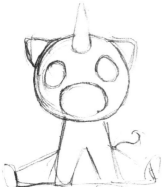 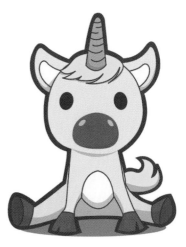

Supercool Chick

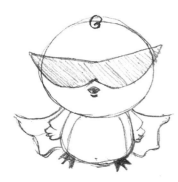 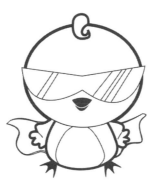 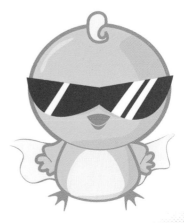

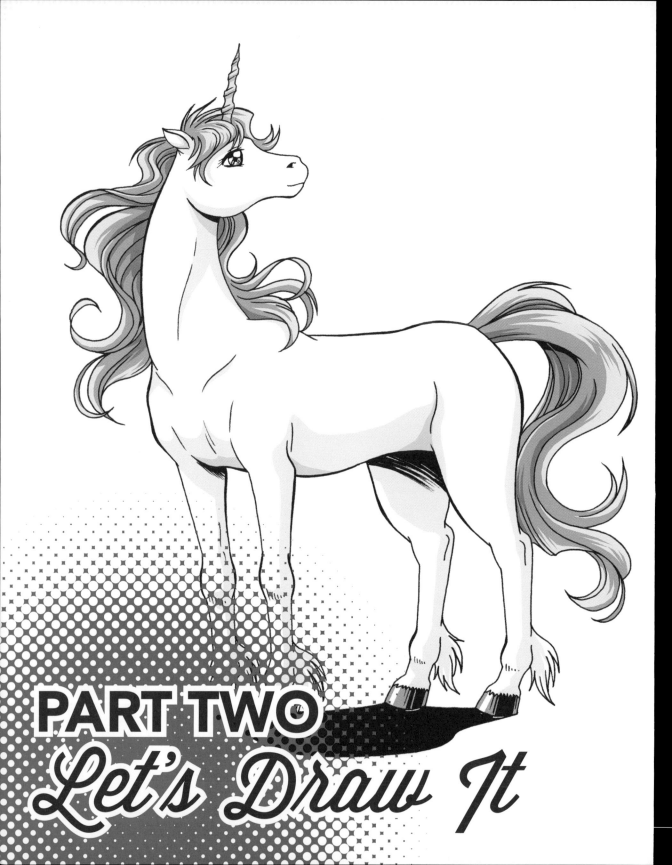

PART TWO
Let's Draw It

Young Cow

Believe it or not, just like cats and dogs, cows have muzzles. This cow has an oval-shaped muzzle, with a half-smile drawn inside. The ears sit on a diagonal on the head, and the cow's horns curve inward toward each other. Round off the bottom of the hooves to make them consistent with all the round shapes found in this animal. Finally, give the cow's tail a little curving motion, instead of drawing it stick straight.

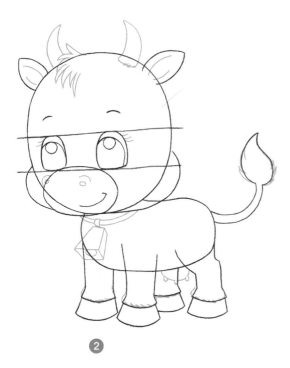

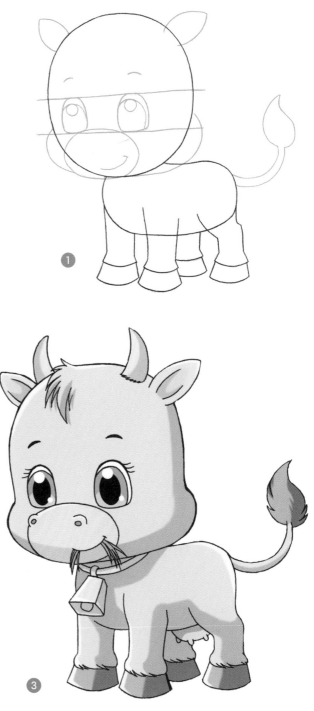

Roly-Poly Penguin

This is a penguin drawn in the kawaii style, which, as you've learned, is simple yet adorable. This guy is practically a blue-and-white beach ball with a beak! Generally speaking, the rounder something is, the cuter it is. Note that the center line curves to the left, as the penguin is in a 3/4 view. His two-toned marking is emblematic and crucial to his identity—otherwise, we might not know he's a penguin. Is he all head, all body, or both? Science may never know the answer.

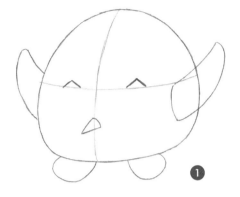

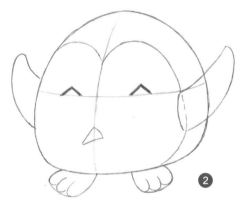

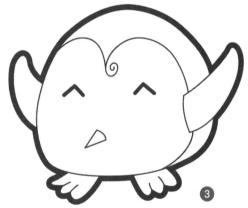

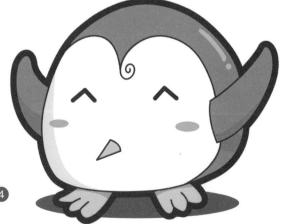

Little Mouse

Don't draw a long snout on this mouse, or you'll turn it into a rat! A manga mouse has a tiny nose. This guy's paws are small and mittenlike, and his bottom is plump! Give him a lot of fur ruffles on his head, ears, and hind legs to finish off the look.

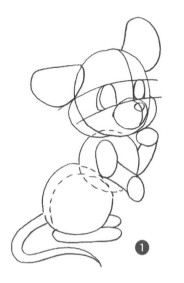

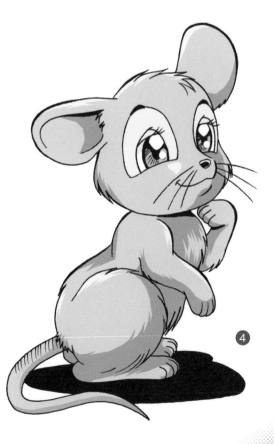

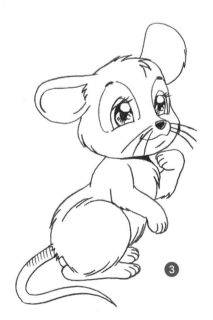

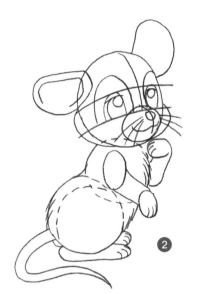

Pink Raccoon

Here's a fun, alternative way to draw a raccoon. The bottom of this raccoon's head is shaped like a football, similar to the face shape you saw earlier. We've kept the same characteristic traits, like the eye mask and striped tail, but played with the color. Keeping certain classic features that are unique to an animal lets you experiment with other aspects, such as its coloration, the length of its fur, etc.

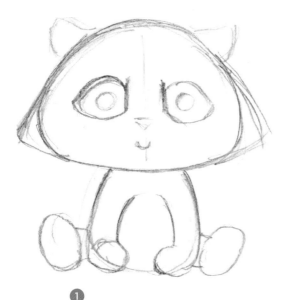

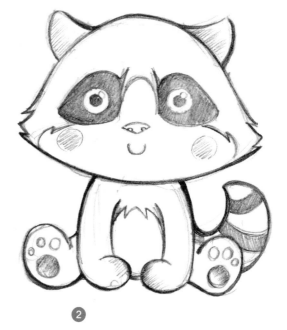

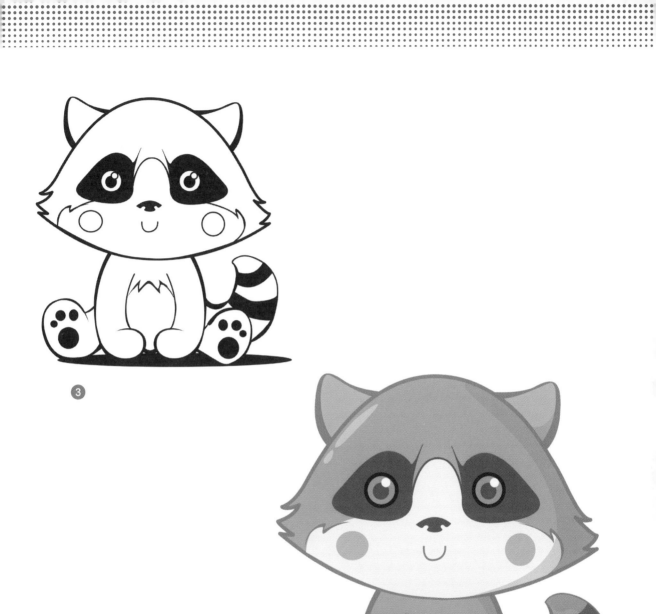

3

Puppy

The key to any baby animal is to keep things round. This puppy's body is an elongated oval, and its eyes and head are circular. Add a little tuft of fur on the top of the head, and stick the pup's tongue out to add an element of personality. This puppy has short ears that fold over.

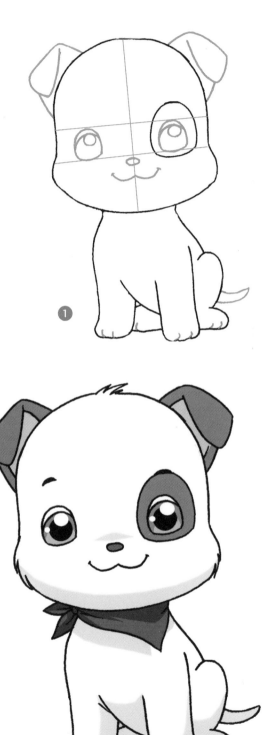

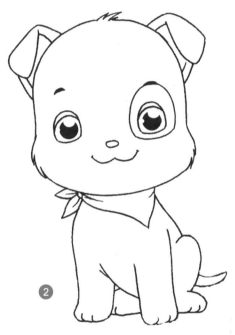

A Couple of Kittens

This kitten's head is much bigger than its body, making it look adorable. It's important to note that cats have a split lip, meaning that the mouth looks like two *Us* joined together at the center. This will give your drawing that characteristic look of a cat. Make the ears triangular, but not too pointy. Have fun wih the tails—one of these kitties has a smooth tail, and the other's is bushy and fluffy.

Chipper Chipmunk

You can't believe how tiny chipmunks are until you see them! You can recognize these critters instantly by their brown and white markings. This chipmunk here has an adorably round head and small nose. His small legs strike a cute contrast with his pudgy body. Don't forget that the chipmunk's ears are black, which is a detail some artists miss.

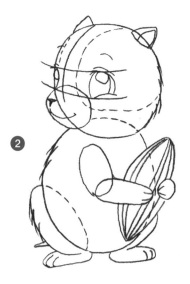

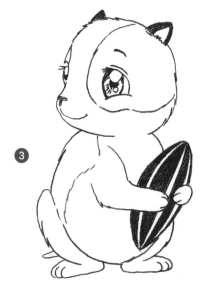

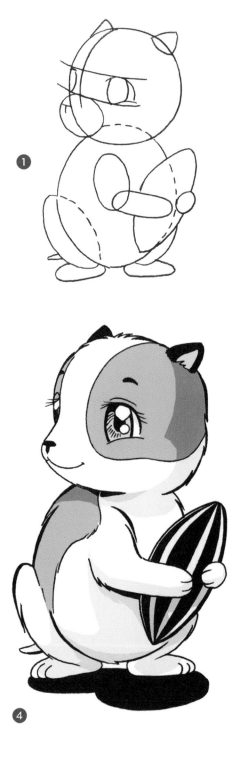

Tiger

Although this tiger is a wild animal, it's still adorable. Give your baby tiger a split upper lip, and plenty of fur ruffles inside the ear and on its chest. The bottom of the eyes are flat, which helps give it that catlike appearance. Also, the tail is never straight—make sure it curls. A special detail of the tail is its tip, which is all black, as if the tiger dipped it in ink!

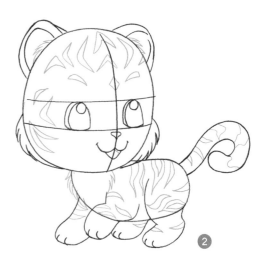

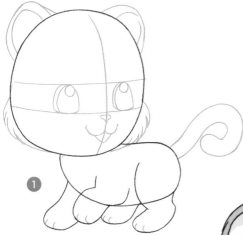

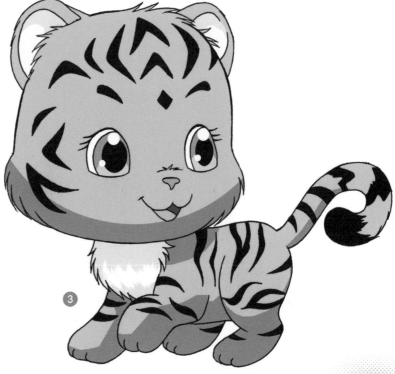

Tortoise

This tortoise is turned a little, so its mouth appears off to one side. Notice how the pattern on its shell curves, and a bit of the underside of the shell is also visible. Short, wide legs make this a cute tortoise.

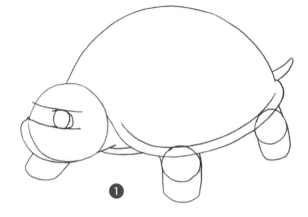

①

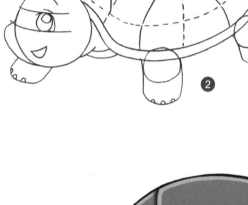

②

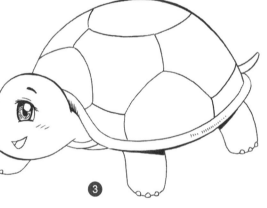

③

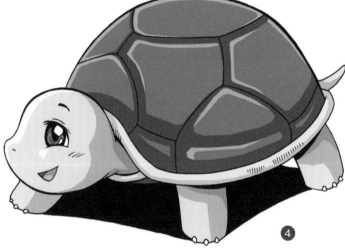

④

Little Turtle

This turtle has been greatly simplified to focus exclusively on its cute aspects, so we've eliminated the details. Gone is the protruding shell just beneath the neck.

What remains from the original are the horizontal shell, the green color, the tile pattern on the shell and . . . that's about it! And yet, by maintaining those three iconic elements, it still looks unmistakably like a turtle.

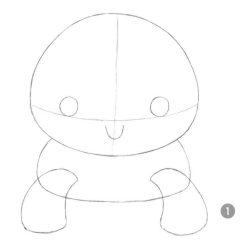

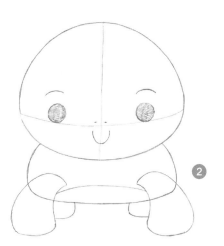

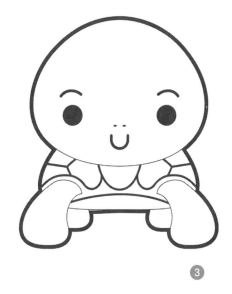

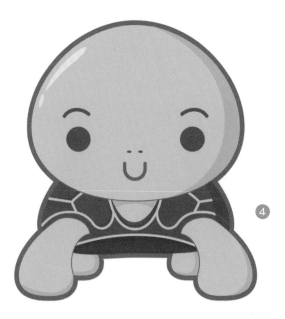

Baby Deer

It's important, as an artist, to recognize what shapes trigger certain reactions, so you can use those shapes to manipulate your viewers' emotions. For example, an oversized round (or oval) head often triggers a sympathetic response from a viewer. This baby deer has a compact, round body, which is cute. Also, keep the antlers' tips round, so they look friendly and non-threatening.

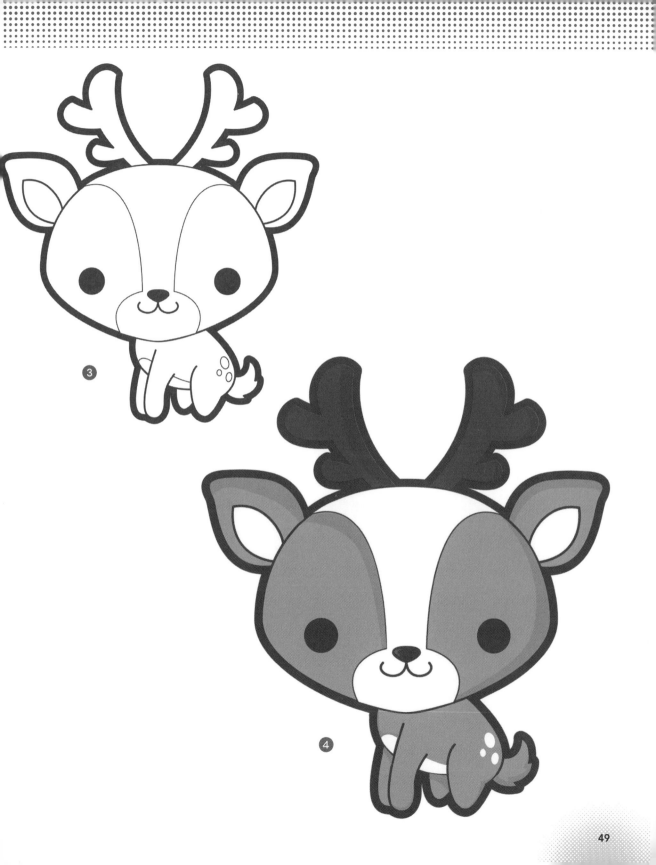

3

4

Doe

Deer have long bodies, and long and slender legs. With a small, delicate muzzle, they appear to be very graceful. An important detail to notice on this deer is that it has split hooves, indicated by lines running down the center of each hoof. Keep antlers modest, or the deer will look aggressive.

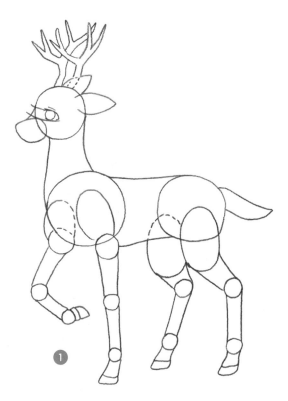

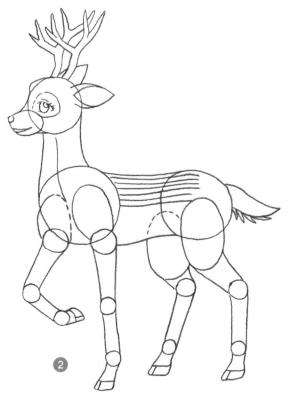

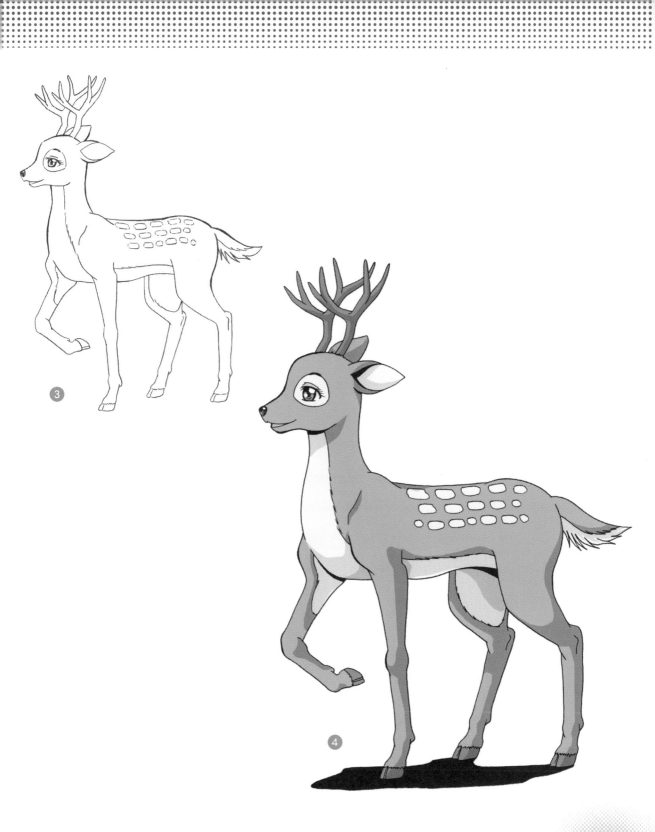

3

4

Unicorn

The unicorn is the most popular fantasy animal in shoujo manga. The original unicorn depicted in art was an aggressive, bearded beast, but over the years, it has evolved into a sweet, serene animal—one that brings joy and light with it. As you can see, its body construction is based on circles—even the joints of its legs are indicated with circles. Give your unicorn a graceful, flowing mane, and a horn that has a twisted, spiraling texture.

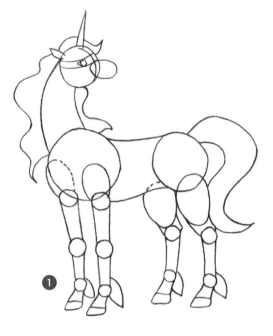

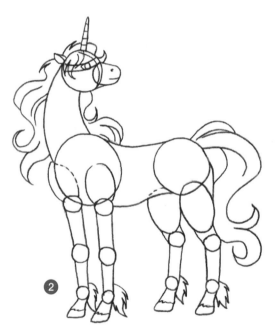

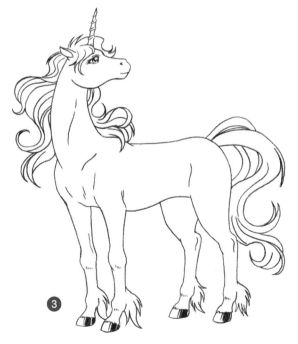

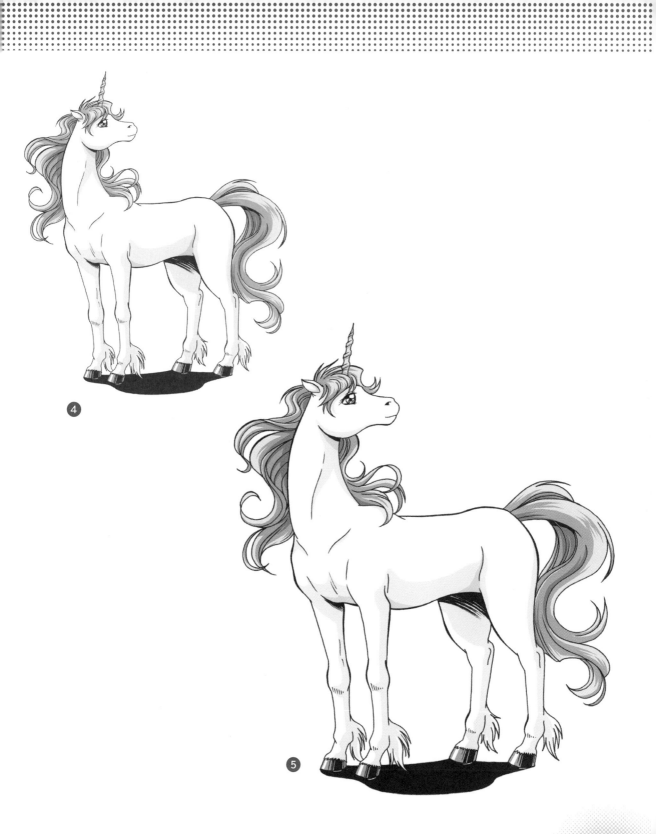

4

5

PART THREE
Let's Practice It

Draw the tails on these animals.

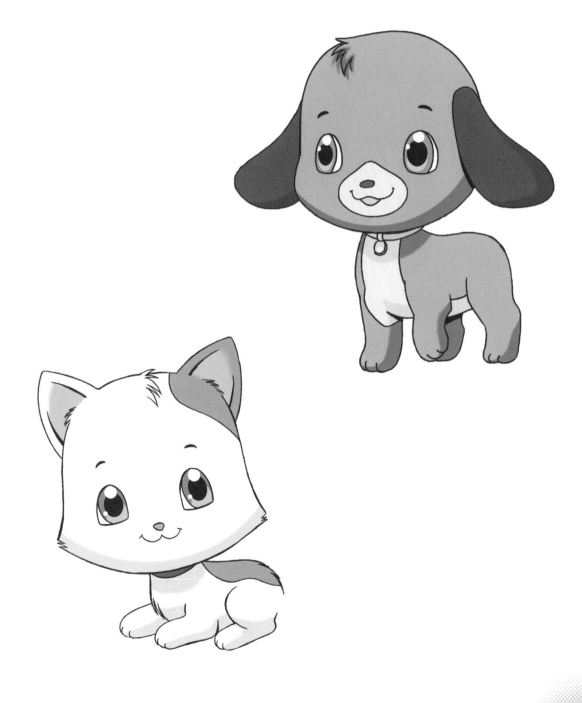

Draw the body on this kangaroo.

Finish the drawing of this bear, and turn it into a panda bear.

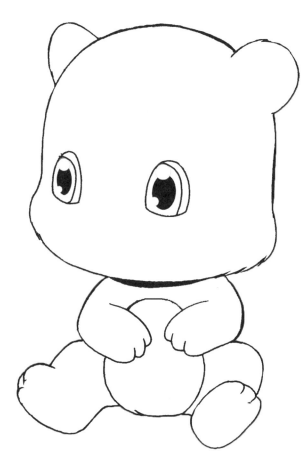

Finish drawing this rabbit.

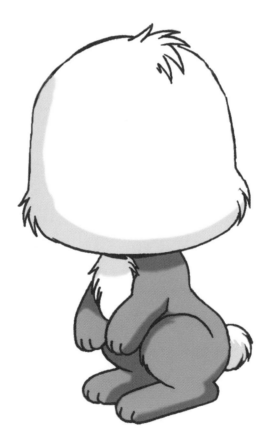

Draw the fins on this shark.

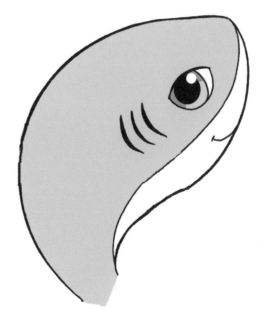

Finish drawing this deer. She'll need ears, a tail, and distinctive markings.

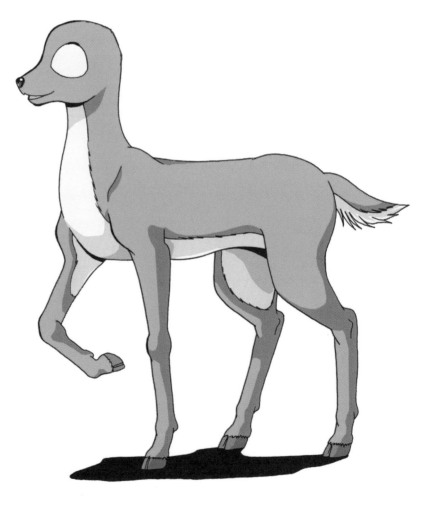

Draw the stripes on this tiger.

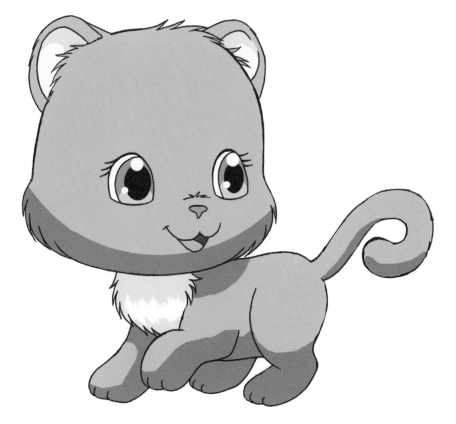

Draw the manga versions of these animals.

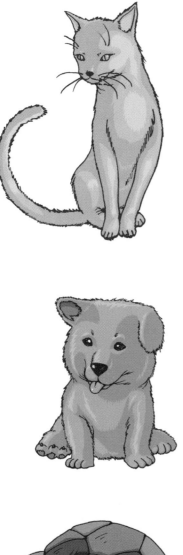

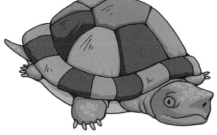

Draw the manga owner of this animal.

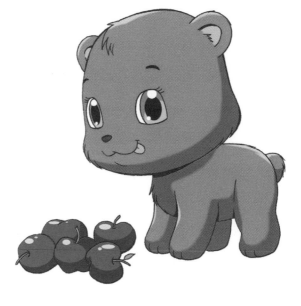

Also available in *Christopher Hart's Draw Manga Now!* series